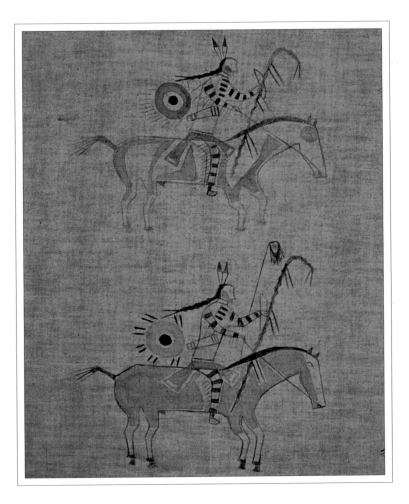

LAKOTA

SEEKING THE GREAT SPIRIT

NATIVE AMERICAN WISDOM

CHRONICLE BOOKS
SAN FRANCISCO

A Labyrinth Book

First published in the United States in 1994 by Chronicle Books.

Copyright © 1994 by Labyrinth Publishing (UK) Ltd.

Design by Meringue Management

The Little Wisdom Library–Native American Wisdom was produced by Labyrinth Publishing (UK) Ltd. Printed and bound in Singapore by Craft Print Pte. Ltd.

Library of Congress Cataloging-in-Publication Data: Lakota, Native American Wisdom.

p. cm. (Native American Wisdom) Includes bibliographical references.

ISBN 0–8118–0450–X

1. Lakota Indians—Folklore. 2. Lakota Indians—Social life and customs.

3. Lakota Indians—Philosophy. I. Chronicle Books (Firm) II. Series.

E99. D1L22 1994
398.2'. 089' 975—dc20 92–41822
 CIP

Distributed in Canada by Raincoast Books,

112 East Third Avenue, Vancouver, B.C. V5T 1C8

10 9 8 7 6 5 4 3 2 1

Chronicle Books

275 Fifth Street, San Francisco, CA 94103

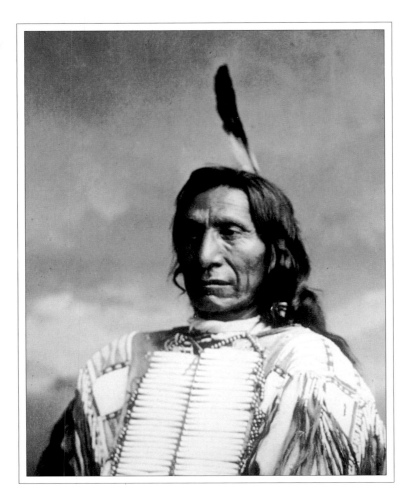

Introduction

Around the world, when the words "American Indian" are read or heard, the mind's eye conjures up a specific image. Invariably it features a bronze-skinned, eagle-feathered warrior on horseback somewhere within North America's central grasslands. He might be chasing after buffalo, arrow nocked in his bow, clinging to his mount by legs alone. He might be in the company of others, equipped with lance and tomahawk, swooping down on a suddenly alarmed wagon train of pioneers. He might be at a standstill, erect on his pony, arms cradling a long pipe, as he inscrutably scans the far horizon, meditating on his place in the universe.

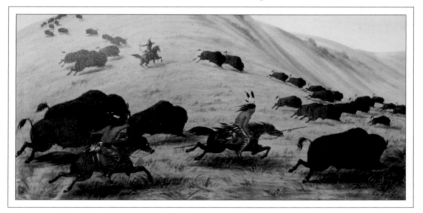

The Hollywood dream factory popularized these visual stereotypes, most recently and successfully in *Dances With Wolves* (1990), but filmmakers did not create them. Euro-Americans in the nineteenth century who encountered the plains Indians marveled at their prepossessing appearance and feared their warrior prowess as an obstacle to the frontier's advance. Even before the warfare was concluded, dime novelists and wild west shows made these "horse Indians" into the quintessential Native Americans, and the movies did the rest. The most numerous and formidable, and thus the most famous, were the Lakota, called the Sioux.

Unfortunately the image-makers worked their cinematic and literary magic all too well. The Lakota people, subdivided into numerous culturally and linguistically linked groups, many still living on plains reservations, are better known for defeating Custer's Seventh Cavalry at the Little Big Horn (a place they knew as the Greasy Grass River) in 1876, than as an enduring people of the twentieth century. Within the span of the Red Power movement of the 1960s and 1970s, the Lakota came into sudden and rather brief focus when the political and military confrontation at

Page 4: Detail of a Lakota painting on cloth.
Page 7: Red Cloud (1822-1909) Chief of the Oglala tribe. *Page 8:* Dyed porcupine quills were used to create this design on a buffalo-hide robe.
Opposite: "Sioux Hunting Buffalo"—Painting by George Catlin, early recorder of Native American life on the Great Plains.

Wounded Knee in 1973 attracted national and international media coverage. Generally, however, the Lakota continue their reservation existence, marked by severe economic and health problems, largely ignored by the rest of the world, their Hollywood "history" serving to prolong a romanticization of the past robust self-sufficiency at the expense of the living tribe.

Now that the world is facing the consequences of centuries of careless misuse at the hands of exploiters, as the United States frets over a divided and alienated populace, some are turning to the country's original inhabitants for possible answers to seemingly insuperable problems. All kinds of seekers after help and spiritual sustenance approach tribal peoples for traditional guidance to living in harmony. Unfortunately for those born to the world view of the European West, an extraordinary mishmash of half-understood constructs easily results.

Not all of the traditions, customs, and

Above: Decorative paintings often relate stories of the outstanding exploits of the artist.

beliefs of Lakota life are chronicled; that would require an undertaking of many millions of words that, even if it somehow offered the experience of those words, would still fall short of comprehensiveness. But considering elements of the tribal wisdom can develop a sense of the whole.

In Lakota wisdom, a principal element is what many Native Americans refer to as the sacred hoop of life. This is a world view, physical and metaphysical, of the whole circumscribed by a circle or hoop. Within the circumference all is alive and interconnected— trees, rocks, wind, stars, animals, and humans. What Western thought categorizes and divides into animate and inanimate, living and dead, earth and sky, plant and

animal, then philosophizes and theologizes in attempts to explain these binary forms, the Lakota embraces as one, joined by spiritual essences that make up a discrete and balanced world.

The liability of such a unified existence is the need for constant balance to maintain the inviolability of the sacred circle. The Lakota have achieved and preserved this delicate mean through ceremony and ritual. When their hoop was penetrated by Euro-American outsiders, they faltered, then discovered new ceremonies to cope with new realities. This volume celebrates the continuum of belief that sustains Lakota life and culture.

Terry P. Wilson

Professor of Native American Studies
University of California, Berkeley

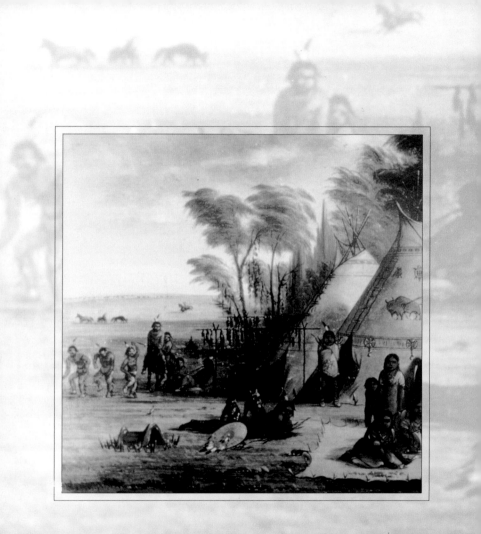

The Life of
the Lakota

Before the Euro-Americans nearly destroyed the Lakota's basic way of life at the end of the nineteenth century, they were the great masters of the North American plains and prairies, feared and respected by other tribes from the Great Lakes to the Rocky Mountains. The area of the Great Plains, which today stretches west from the Mississippi River valley to the Rocky Mountains, and south from varying latitudes in Manitoba, Saskatchewan, and Alberta to southern Texas, was in the past a predominantly treeless expanse of grassland; miles and miles of perfect grazing land for the large, shaggy-maned North American bison. The tribes were nomadic and fierce, living in tipis that permitted them to break camp easily and follow the bison as

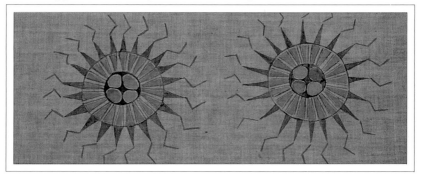

they migrated in search of new grazing land when one area became depleted.

During the course of the seventeenth and eighteenth centuries, the Lakota migrated from the lands in the upper reaches of the Mississippi River where their ancestors had settled more than a century earlier. Constant war with the Cree and the Ojibwa (also known as Chippewa or Anishanaabe) Indians, who had been given firearms by the French, forced the tribe to move west. The three major Lakota subgroups established themselves in new territories: the Eastern, or Santee group, still near the Mississippi River in what was to become Minnesota; the Central group of Yankton and Yanktonai settled along the Missouri River; and the Western, or Teton group, in the badlands and Black Hills of South Dakota

The Native American culture of the Great Plains, of which the Lakota form part, is unique in the

Page 14 : "Sioux Village" by painter George Catlin. *Opposite:* Images of the Sun feature in this painting on cloth. *Above:* Decoration on this drum head signifies the four cardinal directions.

sense that the typical way of life of the nomadic tribes evolved long after the first contact with Euro-Americans. When the Spanish introduced the horse to the continent, life in the plains took a new turn. With increased

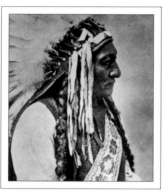

mobility and prowess, the former village and farming tribes of the river valleys turned to nomadic hunting, especially of the buffalo. The large herds of bison and the vastness of the territory (the grasslands covered nearly a

fifth of the total North American land) attracted many other tribes to the plains. Being linguistically distinct, the different tribes developed a unique system of sign language. It became the common way of communication.

It is possible to get a preliminary feel of Lakota life from the way they lived on the plains, in large camps of tipis fashioned from bison hide and with a smoke hole at the top, horses grazing nearby,

bison meat drying on poles, and a sweat lodge for purification rites. This vision has been shown countless times in feature films, usually in a romantic fashion, but also shown more accurately in the accounts of those who first met with these peoples.

Having adopted the plains as their new home, with time the Lakota became the largest tribe there; by the nineteenth century they had acquired guns and formed alliances with the neighboring Cheyenne and Arapaho. They had relatively little contact with the white man prior to the middle of the nineteenth century, but thereafter their situation changed for the worse. Hungry for land and new trade routes, the early settlers staged a series of confrontations that deeply damaged the Lakota spirit. The Sioux Wars, which lasted for thirty-eight years, were among the bloodiest of all the Indian wars that were fought in North America. They culminated with the tragic massacre of two hundred Indians, including women and children, at Wounded Knee on December 29, 1890.

Opposite: Sitting Bull (1834-1890), famous chief and statesman of the Hunkpapa tribe.
Opposite and above: Beadwork, feathers and buffalo fur decorate these sacred pipes.

The people of the "Sioux" tribes of North America are many and varied. The name Sioux derives from the pejorative term *nadowessioux*, meaning "snakes," and was applied to the people who call themselves Lakota by their Algonquian-speaking enemies the Ojibwa. This book is about all the Lakota people who continue to use that name for themselves (as many scholars do now) and, in the Santee and Teton dialects, also "Dakota" and "Nakota."

The Lakota tribe is divided into three main subgroups:

1. the Eastern or Santee group, comprising the M'dewakaton, Santee, Sisseton, Wapekule, and Wahpeton clans;

2. the Central group, with the Yankton and Yanktonai clans;

3. the Western or Teton group, consisting of the Blackfoot Sioux, the Brulé or Sicangu, Hunkpapa, Mnikowoju, Oglala, Sans Arc ("Without Bows," also known as Itazipco), Teton, and Two Kettle.

Opposite: Portrait of Chief American Horse of the Oglala tribe, taken in 1898 by F. A. Rinehart.

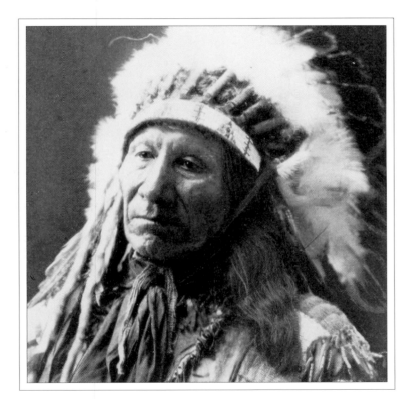

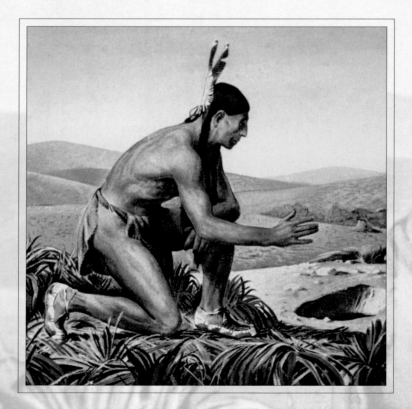

Lakota Wisdom

For the Lakota, the very source of wisdom and the basis for their rituals lie in their mystical participation with the environment. They see themselves as an integral part of a large ecosystem that once encompassed the buffalo, the horses (once they were introduced by the Spanish), and the other animals that lived on the plains, along with the tall grasses and other forms of life. Every aspect of this complex ecosystem, including the Earth, the sky, night and day, the Sun, the Moon, and the stars, was part of,

Mi taku oyasin.
"We are all related."

—*Words spoken at the end of every Lakota pipe-smoking ceremony*

and intrinsic to, this subtle synergy. These were the elements of oneness within which life was undertaken.

The Lakota sustained themselves wholly from the bounty of the plains. The bison provided nearly everything—food, homes, cooking utensils, and clothing. Bison wool was woven, and the hide used to make leather garments. Even the bison ribs were used to make sleds for the children. The feathered headdress used for ceremonies and worn in battle was made of feathers from

Previous page: The "Cave of the Winds" shown in this painting is located in the Black Hills of North Dakota and signifies the place of the first man's emergence in the Lakota tradition. *Right:* Details of a vision quest are portrayed in this painting on cloth.

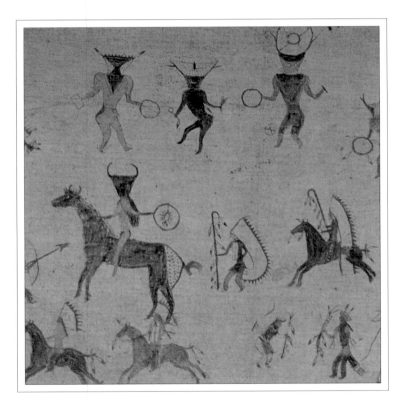

sacred birds, such as eagles, hawks, and owls, which were regarded as messengers from the gods. Feathers were used both for ceremonial decorations and for offerings, as well as for directing the flight of their arrows. Each feather in the headdress represented a victory in battle or an exploit.

Although the buffalo are gone, and "battles" have different requirements, the tradition remains. Many of the focal points of Lakota religion and rituals involve the calling of the supernatural powers from earlier times to grant success in buffalo hunting and protection from an often hostile and unpredictable environment.

Opposite: German reproduction of a George Catlin painting depicting a Lakota puberty rite commonly known as the "Buffalo Ceremony."

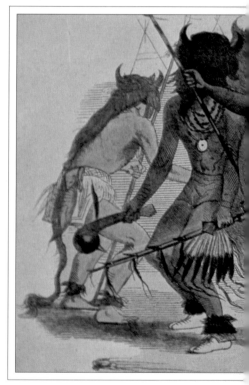

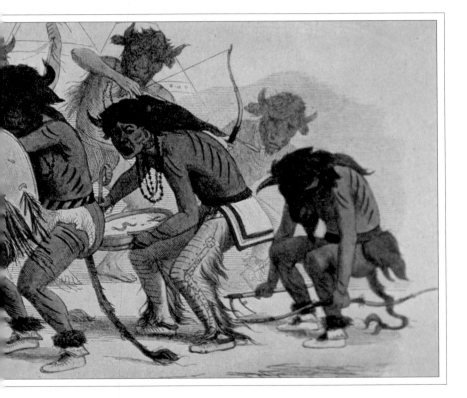

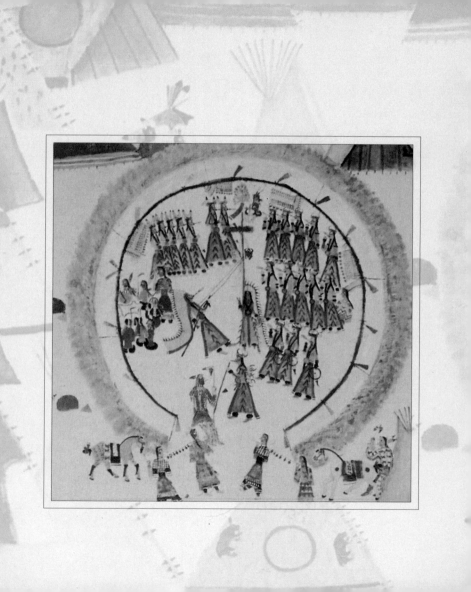

The Sun and Moon
of the Lakota

To comprehend the wisdom of the Lakota one must know the teachings and ceremonies that give it life. The Lakota cosmology reflects in microcosm the elements of their existence. The sacred unity of all these elements is represented as Wakan-Tanka, translated roughly as the Great Spirit, or the Great Mystery.

Several spiritual entities feature in the traditional Lakota creation accounts, and include Takuskanskan ("something that moves");

the Sun, his wife the Moon, and their daughter Wohpe ("falling star"); and Old Man and Old Woman, whose daughter Ite ("face") is married to Wind, with whom she has four sons, the four Winds.

The pantheon of spirits represented in the Lakota teachings are both malevolent and benevolent, and one of the most important is called Inktomi ("spider"), a devious trickster character. Inktomi conspires with Old Man and Old Woman to enhance their daughter Ite's status by arranging an affair between her and the Sun.

But when the Moon discovers her husband's affair, Takuskanskan intervenes in the matter and separates the Moon from the Sun, initiating the creation of time.

Old Man, Old Woman, and their daughter Ite are sent to Earth, but Ite is separated from her husband Wind, who, with his four sons and a fifth child who some say is a child conceived in the affair between Ite and the Sun, creates the dimension of space. Wohpe, the daughter of the Sun and the Moon, falls to Earth and lives with South Wind, which for the Lakota is the incarnation of maleness.

Page 28-29: Watercolor painting of the Sun Dance by Short Bull, Chief of the Oglala, c. 1930.
Opposite: A ceremonial blanket decorated with eagle feathers and other symbols from traditional Lakota teachings.

The two adopt the fifth child, who never grows up, is always playful, and sometimes causes mischief. He is called Umi, or Yum, meaning "whirlwind."

Once landed on Earth, Ite finds her people, the Buffalo Nation. In the guise of a wolf, she searches beneath the surface of the Earth until she discovers a village of humans. Inktomi, the trickster, convinces one man, Tokahe ("the first"), to follow him up to the surface of the Earth. He reaches the surface through a cave, now represented by Wind Cave in the Black Hills of South Dakota, and sees the green grass of the plains and the blue sky for the first time. Inktomi and Ite introduce Tokahe to buffalo meat and soup, and to hunting implements. Full of marvel at his new discoveries, Tokahe travels back under the surface of the Earth and convinces six other men and their families to follow him to the new world. When they

Above: A warrior's shield depicts the buffalo, which possesses the power of the whirlwind to confuse and frighten enemies. *Right:* Pipe bag decorated with beads brought by early European traders to North America.

reach the surface for the second time, however, Tokahe and his companions discover that Ite has cheated them: buffalo are scarce, the weather is harsh, and, unable to find food, they starve. However, though they cannot return to their previous dwelling, the people survive in this new environment and are the founders of the Seven Fireplaces. These Seven Fireplaces rarely feature prominently in Lakota narratives recorded during the past century, probably because of the shift, influenced by the arrival of the Spanish and their horses, from the settled agricultural societies of previous times to a more nomadic way of life.

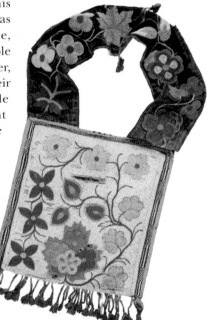

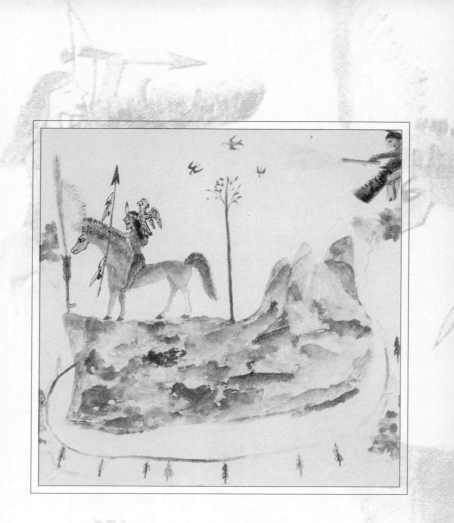

The Ritual Pipe
and the
Seven Sacred Rites

Other essential elements of Lakota wisdom are the smoking of the pipe and seven sacred rites, handed down from generation to generation. These come through a beautiful legend, which relates the appearance of White Buffalo Woman before two Lakota warriors. This woman demonstrated her sacred powers by reducing one of the two young warriors to a heap of bones. She instructed the other to tell his

chief that she was coming to see him and his people with a message of great importance.

When everything had been prepared for her arrival, she appeared miraculously before the chief and his tribe, removed a bundle from her back, and held it toward the chief, saying that it contained a holy pipe to be used to send messages to Wakan-Tanka, their "Grandfather and Father":

Previous page: A watercolor painted by Standing Bear depicts the major elements of Black Elk's vision of the "sacred hoop" of the universe. *Above:* Painted buffalo-hide robe featuring an image of the Sun. *Opposite:* Pipe bag decorated with quillwork.

With this sacred pipe you will walk upon the Earth, your Grandmother and Mother. Every step taken upon her should be as a prayer. The red-stone pipebowl is the Earth. The buffalo calf carved upon it represents all the four-leggeds that live upon your Mother; the wooden stem, all that grows upon her; and these twelve feathers hanging where the stem enters the bowl are from the spotted eagle, representing all the winged ones. For when you smoke this pipe, all things of the universe are joined with you and lift their voices to Wakan-Tanka.

After she had presented the pipe, with instructions for its use, the narrative continues: *She moved around the lodge sunwise and went out, and as she walked, a white cloud came from her mouth that was good to smell. But after going a short way, she looked back and sat down. When she rose, she had become a red and brown buffalo calf, which walked a little way, lay down, looked back at the people and rolled on the ground. Then she got up and had changed into a white buffalo cow, which walked on, and again rolling on the ground, became next a black buffalo, which walked away, stopped, and after bowing to each of the quarters of the world, disappeared over a hill.*

Thus it happened that White Buffalo Woman established for the Lakota that whenever the sacred pipe was smoked, "all things of the universe" would be joined with the tribe, and all would lift their voices to Wakan-Tanka. The ritual smoking, fundamental to all Lakota tribes, remains today a ritual of bonding and a bridge between the people and their universe. In the words of Black Elk, perhaps the most famous of the Lakota tribe chieftains:

...I fill this sacred pipe with the bark of the red willow; but before we smoke it, you must see how it is made and what it means. These four ribbons hanging here on the stem are the four quarters of the universe. The black one is for the west where the thunder beings live to send us rain; the white one for the north, whence comes the great white cleansing wind; the red one for the east, whence springs the light and where the morning star lives to give men wisdom; the yellow for the south, whence come the summer and the power to grow.

But these four spirits are only one Spirit, after all, and this eagle feather here is for that One, which is like a father, and also it is for the thoughts of men that should rise high as eagles do. Is not the sky a father

and the earth a mother, and are not all
living things with feet or wings or roots
their children? And this hide upon the
mouthpiece here, which should be bison
hide, is for the earth, from whence we
came and at whose breast we suck as
babies all our lives, along with all the
animals and birds and trees and
grasses. And because it means all this,
and more than any man can under-
stand, the pipe is holy.

A simpler and more earthy but no
less evocative description of the
pipe and its uses is given by
Luther Standing Bear. He tells of
the "breaking of camp" by his
people and their pilgrimage to
follow the buffalo:

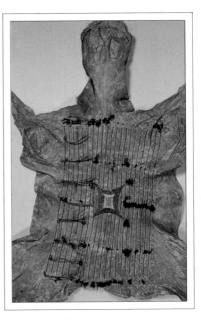

Opposite: A child's wooden doll, from the Wahpeton
tribe in South Dakota. *Above:* Quillwork decorates a
skin used in packing household belongings for travel.

The old men of the tribe would start out first on foot. They were always in front, and we depended on them. They were experienced and knew the lay of the land perfectly. If the start was made before sunrise, it was beautiful to see the golden glow of the coming day. Then the old men sat down to wait for the sunrise, while the rest of us stood about, holding our horses. One of the men would light the pipe, and as the sun came over the horizon, the entire tribe stood still, as the cere-mony to the Great Spirit began. It was a solemn occasion as the old man held the bowl of the pipe in both hands, and pointed the stem toward the sky, then toward the east, south, west, and north, and lastly, to Mother Earth. An appeal was made during this cere-mony; the men smoked, after which the pipe was put away. Sometimes there would be something to eat on these occasions. After this ceremony was over, somehow we felt safer to go on.

> With visible breath
> I am walking.
> A voice I am sending
> as I walk.
> In a sacred manner
> I am walking.
> With visible tracks
> I am walking.
> In a sacred manner I walk.
>
> —*The Song of White Buffalo Woman as she presented the sacred pipe to the Lakota*

Right: A roach (usually made from a deer's tail) with eagle feather, used as a headdress in ceremonial dances.

Along with the sacred pipe, White Buffalo Woman gave the Lakota the first of their seven sacred ceremonies, the ceremony of the spirit-keeper. She said that six more sacred ceremonies would follow, brought by those who had returned from individual vision quests.

The gifts of White Buffalo Woman provide the Lakota with the basis for their entire lifestyle, the ground, the ritual, and the practice that they still employ today. The complex of seven sacred rites is known as Wicoh'an Wakan Sakowin, and it is made up of the following ceremonials: the sweat lodge, the vision quest, the sun dance, spirit-keeping, making relatives, the puberty ceremony, and throwing the ball.

The Sweat Lodge Ceremony: Inikagapi

Inikagapi means "renewal of life" in the Lakota language, and this is a ceremony of ritual spiritual, physical, and mental purification. A special structure is built from saplings for the purpose, and its domed shape is covered in buffalo skins, symbolizing the shape of the universe.

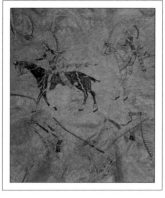

Within the sweat lodge the floor is often carpeted with boughs of wild sage. Heated stones are placed in a central hole and a medicine man pours water over them, much in the manner of a sauna, to create steam and raise the temperature. The participants of the ceremony usually fast in order to promote a greater physical cleansing. The Lakotas cleanse both the spirit and the body, especially before undertaking an important task, such as a vision quest. The process enables clarity of purpose and absolute focus.

Above: Painted skin used for transporting belongings. *Right:* A shield painted with totem animals whose spirits can help the owner in combat.

The Vision Quest: Hanbelachia

The vision quest is a fasting vigil undertaken by both men and women after puberty and, in many cases, periodically throughout their lives. In this holy quest a message from the spirit world is sought and given in the form of a vision. The individual undertaking the vision quest must pledge to remain in an isolated spot for one to four days and takes very little or no water or food during this period. The ritual fasting, the solitude, and complete immersion in the natural world enable the seeker to shift to another level of consciousness where archetypal essences can appear in animal, human, or plant form. The appearance of plants is often connected with the seeker's being given knowledge of their healing powers. If an animal appears, this might become the "totem animal" and guardian spirit of the person. Each animal possesses particular powers that give character and intelligence (*see "Animal Qualities"*). However the vision manifests itself in the quest, a path is made clear, a mystery is unveiled.

After receiving the vision, the individual returns to camp, where a sweat lodge has been prepared. Within the lodge the hidden meaning of the vision is interpreted by a medicine man who recommends the steps to be taken or the path to be followed that will ensure actualizing the full power and purpose of the vision. Special symbols may be derived from what was experienced in the vision, and these may be reproduced on the tipi, gathered into a sacred "medicine bundle," or sculpted in sacred art forms. These symbolic repre-

The birds and beasts, the trees and rocks, are the work of some great power. Sometimes men say that they can understand the meaning of the songs of the birds. I can believe this is true. They say that they can understand the call and cry of the animals, and I can believe this also is true, for these creatures and men are alike, the work of a greater power . . . we believe that he [Wakan-Tanka] is everywhere.

—*Chased by Bears*

sentations then serve as aids in retaining or exercising the special powers or knowledge given by the vision. Songs may also be revealed during the quest. One of the suggestions of the medicine man when the seeker returns from a vision quest might involve a reenactment of the vision for the rest of the tribe, which could include the singing of these songs or chants. Thus the person who has received the vision is able to relive its message and force, its meaning is intensified, and the whole group is able to participate in and benefit from the experience.

Animal Qualities

The Lakota attribute special powers to the various animals in a complex set of associations that reflect the nature and behavior of the animals, their roles in providing sustenance for the Lakota, and their connections to the various elements of the Earth, such as wind and fire. Here are aspects of three powerful animals.

BISON: feminine creativity, feminine virtue, hospitality, generosity, feminine courage, male strength, male courage, persistence, defense, invulnerability, power over women, power of the whirlwind, power to confuse the enemy, curing power.

BEAR: feminine creativity, masculine strength, courage, persistence, invulnerability, observation, ability to terrify, curing power, ability to find things.

FOX: gentleness, feminine courage, masculine courage, persistence, swiftness, observation, attentiveness.

The Sun Dance: Wiwanyang Wacipi

One observer of the Lakota tribes during the early twenieth century has offered this interpretation of one of the most controversial and least-understood Lakota ceremonies, Wiwanyang Wacipi ("gaze-at-the-sun dance"). P. Beckwith, in a 1926 report to the Smithsonian Institution in Washington, D.C., suggests that this ceremony can be

seen as ...*a complement to the individually oriented "vision quest"... This great complex of solemn rites, ceremonies, fasting, sacred song, and dance fulfills not just the particular spiritual needs of the actively participating individuals, but also those of the entire tribal group. . . . The event is indeed for the welfare of the entire world. These are ceremonies, interspersed with special sacred rites, which* celebrate world and life renewal at the time of spring.

Above: Man's vest decorated with dyed porcupine quills.
Right: Lakota tomahawk. *Following page 48:* Headdress from one of the tribes occupying the Rosebud Reservation in South Dakota in the early 1900s. *Page 49:* A portrait of Black Elk, perhaps the most famous of all Lakota chiefs and spokesmen.

Once outlawed during the latter part of the nineteenth century, the Sun Dance was traditionally performed each year at the time of the Summer Solstice, during the full moon in June or July. Black Elk has explained the significance of the full moon by saying that "the growing and dying of the moon reminds us of our ignorance which comes and goes; but when the moon is full it is as if the eternal light of the Great Spirit were upon the whole world."

In fact, all the elements of the ceremony have symbolic significance. A special structure is built, with a cottonwood tree at the center to represent Wakan-Tanka.

Twenty-eight additional posts are used to create a circle around the central pole, representing the twenty-eight-day cycle of the moon. The whistles made of eagle bone that are played during the dances echo the voice of Wakan-Tanka, and the accompanying drums, the "throbbing pulse of the universe."

Even the aspect of the Sun Dance that has profoundly shocked outsiders, and was a main reason it was outlawed, has a deeper significance than that which is apparent on the surface. During one of the last days of the ceremonial, selected participants were attached to the center pole by means of thongs tied to wooden skewers piercing the skin

of the chest. In breaking free of these skewers in their dance, the men were not just demonstrating their bravery or imperviousness to pain but, as Black Elk explains, "it is as if we were being freed from the bonds of the flesh." In that way, the experience does indeed suggest a parallel to the altered state of consciousness experienced as a result of the fasting and isolation of the vision quest. And in fact the young men who participated in this particular rite of the Sun Dance

"You should know that the buffalo has twenty-eight ribs, and that in our war bonnets we have usually twenty-eight feathers."

—*Black Elk*

ceremonial had prepared themselves for the event during the entire preceeding year, under the close supervision and guidance of a medicine man.

Spirit-Keeping and Other Sacred Rites

Of the remaining four of the Lakota's seven sacred rites, three are still observed today. The spirit-keeping ceremony, which was given directly by White Buffalo Woman herself, is performed by a mourner and is intended to help the soul in its passage from life to death. An important

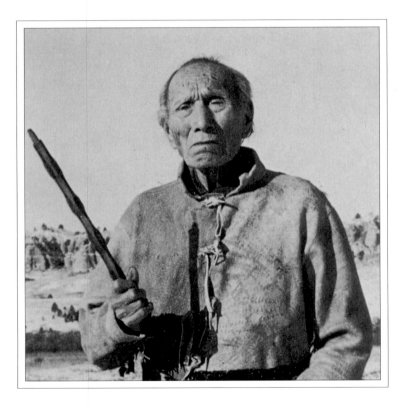

feature of this rite is the presence of a hide taken from a white buffalo, which must be prepared according to a careful procedure that ensures the purity of the rare and precious hide. The "making relatives" ritual, called Hunkapi, is a bonding ceremony between two unrelated persons. The bond created by the Hunkapi ceremony is even stronger than a blood relationship, and involves a sacramental sharing of food between the two persons being joined in this special relationship. The puberty ceremony, described by Black Elk as Ishna Ta Awi Cha Lowan (Preparing for Womanhood), originated from a vision by a Lakota named Slow Buffalo, and is celebrated at the onset of a girl's menstruation. This ceremony is so much centered around the buffalo, who repre-

Above: A dress made of soft leather and decorated with beads and porcupine quills. *Right:* Participants in the Ghost Dance movement of 1890 wore shirts in this style. The movement was finally crushed by the infamous massacre by government troops at Wounded Knee.

sents the "mother" and Earth principle to the Lakota, that early observers called it simply, "the buffalo ceremony." It ensures that the young girl understands and adopts all the qualities of a Lakota woman.

The last of the seven sacred rites, which is no longer practiced, was known as "the throwing of the ball," or Tapa Wanka Yap. It was a kind of game, in which a ball, made of bison hair and covered with a red-and-blue-painted bison hide, was tossed into the air in each of the four directions, and then tossed straight up. The ball represented Heaven and Earth united, or Wakan-Tanka, and whoever caught it would receive a great blessing.

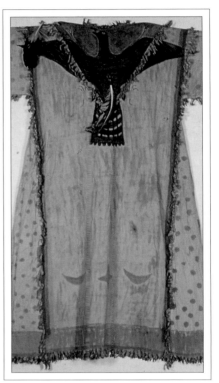

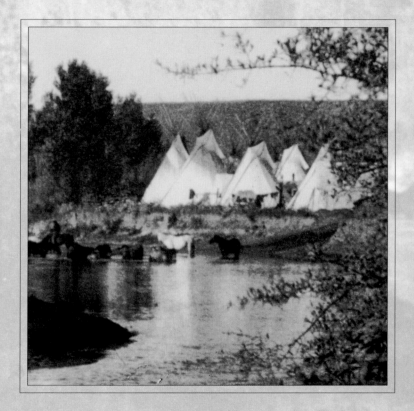

A Story Good
To Tell

When the first white settlers reached the Great Plains of North America, they encountered a landscape for which they didn't even have a name. Many of them recorded their awestruck wonder at this "ocean of grass" and noted its similarity to the sea. The winds and the sunlight and the shifting clouds combined to ripple across the tall grasses in hypnotic, harmonious patterns that had graced these vast prairies for millennia.

The harmony, grace and dignity of these patterns had been both revered and personified by the Lakota for centuries. But the newcomers, in their ignorance and disregard for the profound wisdom of these native people, laid waste to the landscape and most of its inhabitants in the unbelievably short span of fifty years.

Perhaps the most infamous of the white man's acts, apart from the persecution and slaughter of the

Previous page: Photo of Lakota camp, taken by Edward Curtis. *Above:* A bowl carved of wood. Before they were forced onto reservations the Lakota carried no such utensils, instead using animal parts to cook and serve food, and making new clay pots on their arrival at each new camp. *Opposite:* Hunters disguised in wolf hides take part in luring bison towards other hunters.

natives themselves, was the wanton and near total destruction of the buffalo, the "chief of all animals" in Lakota tradition. The settlers also, however unwittingly, destroyed the land itself—first with their plows and cattle fences, and later, following the devastation of the Dust Bowl, with the pollution and waste of their cities and industrial-scale ranches and farms. There are those who say today that the Great Plains never should have been settled at all. They say the land is suited neither to agriculture nor cattle ranching, and its best use would be as a vast "buffalo commons" where the fences would be torn down, the plows would be put away forever, and the grasses would be allowed to grow free. They say, in other

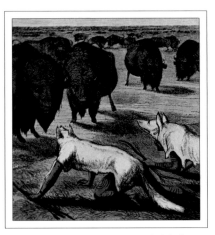

words, that the pattern laid down by nature in the first place was the best one, the wisest one.

But only a few tiny remnants of the original Great Plains remain, in scattered, isolated plots that can only hint at what used to be. Where is one to find the blueprint,

the pattern of color and harmony and beauty in a landscape stretching as far as the eye can see?

The Lakota know the answer to that question. The pattern lies etched in their hearts and minds, the gift of a rich tradition of ceremony and wisdom that sustained them for centuries in freedom, and sustains them still.

They know it, in the words of Black Elk, as "the story of all life that is holy and good to tell, and of us two-leggeds sharing in it with the four-leggeds and the wings of the air and all green things; for these are children of one Mother and their Father is one Spirit."

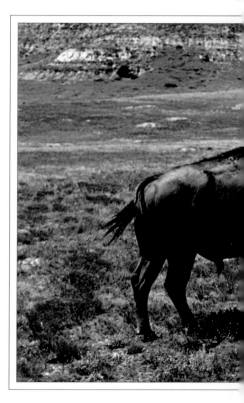

Right: Buffalo are protected today in special reserves like this one in South Dakota.
Page 58: Harness ornament shows exceptionally intricate working of quills and beads.

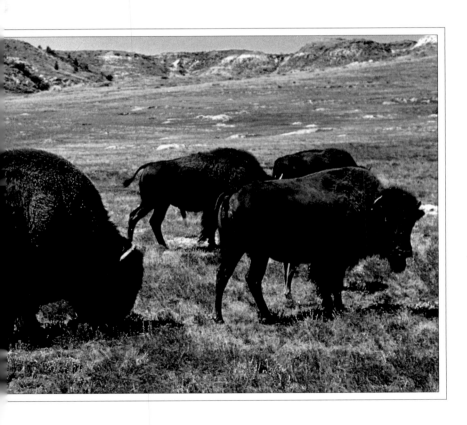

BIBLIOGRAPHY

Brown, Joseph Epes. *Animals of the Soul: Sacred Animals of the Oglala Sioux*. Element Books, Dorset 1992.

Brown, Joseph Epes. *The Sacred Pipe: Black Elk's Account of the Seven Rites of the Oglala Sioux.* University of Oklahoma Press, Norman, 1953.

Neihardt, John G. *Black Elk Speaks*. University of Nebraska Press, Lincoln, 1961.

Standing Bear, Luther. *My People the Sioux*. University of Nebraska Press, Bison Books, Lincoln, 1975.

Sullivan, Lawrence E., (ed). *Native American Religions.* MacMillan Publishing Company, New York,1989.

Crow Dog, Mary, with Richard Erdoes. *Lakota Woman.* Harper and Row, New York, 1990.

DeMallie, Raymond J., ed. *The Sixth Grandfather: Black Elk's Teachings Given to John G. Neihardt.* University of Nebraska Press, Lincoln, 1984.

Eagle Walking Turtle. *Keepers of the Fire: Journey to the Tree of Life Based on Black Elk's Vision.* Bear & Co., Santa Fe, 1987.

Hyde, George E. *A Sioux Chronicle.* University of Oklahoma Press, Norman, 1956.

Lame Deer, John (Fire) and Richard Erdoes. *Lame Deer, Seeker of Visions.* Simon and Schuster, New York, 1972.

Lewis, Thomas H. *The Medicine Men: Oglala Sioux Ceremony and Healing.* University of Nebraska Press, Lincoln, 1980.

Powers, William K. *Sacred Language: The Nature of Supernatural Discourse in Lakota.* University of Oklahoma Press, Norman, 1990.

—. *Yuwipi: Vision and Experience in Oglala Ritual.* University of Nebraska Press, Lincoln, 1982.

Steinmetz, Paul R., S. J. Pipe. *Bible and Peyote Among the Oglala Lakota: A Study in Religious Identity.* University of Stockholm, Stockholm, 1980.

ACKNOWLEDGMENTS

Every effort has been made to trace all present copyright holders of the material used in this book, whether companies or individuals. Any omission is unintentional and we will be pleased to correct errors in future editions of this book.

Text Acknowledgments:

p. 44: From *Animals of the Soul: Sacred Animals of the Oglala Sioux*, by Joseph Epes Brown, Element Books, Ltd., Dorset, Great Britain, 1992.

p. 37: From *The Sacred Pipe: Black Elk's Account of the Seven Rites of the Oglala Sioux*, by Joseph Epes Brown. Copyright © 1953 by the University of Oklahoma Press.

pp. 38–39: From *Black Elk Speaks*, by John G. Neihardt, University of Nebraska, Lincoln, Nebraska, 1961.

p. 40: From *My People the Sioux*, by Luther Standing Bear. Introduction by Richard N. Ellis, Bison Book edition, University of Nebraska Press, Lincoln, Nebraska, 1975.

Back cover: From *Land of the Spotted Eagle*, by Luther Standing Bear, University of Nebraska Press, Lincoln, Nebraska, 1933.

Special thanks go to Terry P. Wilson, Professor of Native American Studies at the University of California, Berkeley. His help in checking the accuracy of information and the sensitivity of the language used in this work has been invaluable.

Picture Acknowledgments:

Reproduced by permission of the National Museum of The American Indian, Smithsonian Institution; Pages: 4, 8, 12, 16, 17, 25, 30, 32, 36, 37, 38, 39, 41, 42, 43, 46, 47, 48, 50, 51, 54, cover.
Peter Newark's Western Americana; Pages: 7, 10, 14, 18, 22, 26, 52 *(Edward Curtis)* 55, 56.
Christie's Colour Library; Pages: 18, 19, 33, 58.
F. A. Rinehart; Page: 21.
American Museum of Natural History, New York; Pages: 28, 34.
Joseph Epes Brown; Page: 49.